Copperplate Calligraphy

by Dick Jackson

COLLIER BOOKS

A Division of Macmillan Publishing Co., Inc.

NEW YORK

COLLIER MACMILLAN PUBLISHERS

LONDON

Macmillan Publishing Co., Inc.
866 Third Avenue, New York, N.Y. 10022
Collier Macmillan Canada, Ltd.

Library of Congress Cataloging in Publication Data

Jackson, Dick.
 Copperplate calligraphy.

 1. Calligraphy. 2. Writing, Copperplate.
I. Title.
Z43.J125 745.6'197 79–14645

ISBN 0–02–011710–8

First Printing 1979

10 9 8 7 6 5 4 3 2

Printed in the United States of America

We who follow a gentle and quiet muse, do not intend to call out those vile calumniators of calligraphy into the arena of honor. We know well that they will be banished to the centaurs and lapiths by the decree of persons of quality and accomplishment who follow the arts & sciences. But enough! Farewell, kind reader, and embrace me and all champions of calligraphy in your perennial favor.

from Calligraphia Latina by Johann Georg Schwandner, 1755

Contents

Introduction

COPPERPLATE. What has copper got to do with a style of calligraphy? The best way to answer the question is to look very briefly at the history of this style.

The direct ancestor, the beginning of the use of a flexible pen to achieve differences in stroke width, was the French Ronde in the seventeenth century. The English quickly adopted and adapted it; much for its economic appeal in being swift in execution, though still neat and legible for use in the rapidly expanding world of commerce. With the growth in demand for clerks who could write this style, there was a corresponding growth in teachers of the style. Their stock in trade was the copybook containing their instructions and examples.

The writing-masters penned their works, then took them to an engraver who could copy all the variations in turn and line thickness in a sheet of copper. These engraved *copper plates* then were used to print the copybooks. The style was at this time called Round Hand or Round Text.

The term "round hand" had been used for other styles and was sometimes referred to as English Round Hand in an attempt to distinguish it from broad-pen styles with the same name. Later on it came to have a number of names including Engraver's Script, Engrosser's Script, or just Script. There seems to be less likelihood of confusion if the style is called Copperplate, so that is the name I will use for it throughout the book.

As the competition among the writing masters both in England and America grew, each strived to make his copybook just a little different, a little "better", than his rivals. In this effort, they took more and more advantage of the ability of the engraver to produce thick or thin lines anywhere in a letter or stroke. As a consequence, they added swirls, flourishes, strikings, and thick and thin strokes without regard to the ordinary position of pen and paper for writing. Some of the instructions directed the student to keep the point of the pen on the paper while turning the paper 180 degrees for the continuation of a stroke.

As a result, much of the Copperplate of the nineteenth and twentieth centuries isn't calligraphed at all; it is drawn.

In this book, I try to maintain Copperplate as calligraphy. There are no paper, pen, or body manipulations required to execute any letter. The strokes comprising the letters are made with ordinary pen movements in an ordinary sequence. In other words, the letters are calligraphed, not drawn.

There is little in this book that is original. I have studied and tried to emulate the work of many authors and writing-masters, old and not so old. Most of what I give you is the distillation of my own study from those many sources. Even a presentation of the minuscules as a combination of a limited number of identical strokes has been done. In 1791, John Jenkins had printed a book titled *The Art of Writing Book I* in which he did this. I haven't

had the honor of seeing the book, but I am aware of its existence and the stroke principle he used. I don't think I knew about it when I first started teaching Copperplate by this approach several years ago. But it works.

The order and emphasis of these instructions are the product of having taught Copperplate to several hundred students. I recommend that you follow the order and heed the emphasis. They work.

Copperplate Calligraphy

Materials

THERE ARE FOUR INGREDIENTS necessary to produce calligraphy of any kind: the pen, the ink, the paper, and the calligrapher. You are, or will be, the calligrapher. So this section will briefly cover the other three components.

You will need an offset (or oblique or elbow) penholder and flexible nibs. The penholder has an offset so that you can aim the nib along the paper at a steeper angle than would be comfortable otherwise. Aiming and angle will be discussed later. The nib is flexible so it spreads when pressure is applied to it and closes when the pressure is released.

The nib, like all metal nibs, is shipped from the manufacturer with a thin film of oil on it. In order for the ink to flow well, this film of oil should be removed. You can do this in several ways. Hold the nib in your mouth awhile and your saliva will remove the oil. They really don't taste all that bad, but a sudden sneeze might create a problem. Spray it with one of the liquid household cleaners, rinse, and dry it. The quickest and easiest way is to hold it briefly over the flame of a match or cigarette lighter. Move it back and forth to get it black all over, but don't let it get red hot. It's a good idea to insert the nib in the holder before you heat it so you don't burn your fingers on the hot nib.

A good paper to learn and practice on is a tablet of translucent white, unruled paper. Having the paper in a tablet serves several purposes that loose sheets won't. The tablet will hold the underlay guide sheets firmly enough so that you won't need paper clips or tape to keep them from slipping. The paper in the tablet will serve as a good pad under the sheet on which you're writing. It's better not to write on a hard surface since any irregularities will affect the pen strokes, and, even if the surface is perfectly smooth, the pen just works better if there is a little padding under the paper. If you don't tear the sheets out, the tablet will serve as a chronological file of your practice efforts. It's great for the morale, when you're a little dejected after some hard practice because you don't feel you are making any headway, to go back through the sheets from previous practices and see just how much progress you've made. It would be desirable for the reader to make tracings of the guide sheets at the back of this book. Guide sheets should then be used as suggested.

Some papers that work well for regular or italic pens may not be as good for Copperplate and vice versa. The only way to tell for sure if a particular paper is good is to try it, or ask another Copperplate calligrapher who has.

Ink for the flexible nib needs to be a little thicker than ink for other pens. A good ink is Higgins Eternal, made slightly more viscous by the addition of ten or twelve drops of gum arabic. This ink dries to a dark, flat black. There are other inks which work very well. Some, like the oriental inks, dry to a glossy finish. A good ink will be viscous enough to allow the nib to hold a full load without it all flowing out when pressure is applied for a dark down-stroke, but thin enough to flow at the lightest possible touch of the nib on paper.

If you don't have gum arabic, you can thicken the ink some by leaving the cap off the bottle and letting the ink evaporate a few days. The number of days depends on how humid the air is. You will soon find that the opening in the standard two-ounce ink bottle is too small to dip your nib in easily, so you may want to get a wider-mouthed bottle. Small baby food jars or some types of medicine bottles serve very well.

Getting Started

Now that you have a nib in your penholder, a bottle of ink at hand, and a tablet of good blank paper, you're anxious to begin learning Copperplate calligraphy. Just one final note of caution before you start. After the first few exercises you will become familiar enough with the flexible characteristics of the pen that you will be able to approximate the letterforms. You can go directly to the letters and begin writing Copperplate. But your calligraphy will always look like just what it is—an approximation. Of course, your friends and relatives will ooh and ah and make all the other appropriate noises of approval and tell you how talented you are. The saddest part of this approach is that it will start to look correct to you, too, and you will continue to make whatever mistakes you're making now. The point is to urge you to follow the instructions step by step, even though the exercises may seem boring and tedious at times. These instructions weren't devised or contrived just for the purpose of writing this book. They are the result of trying and evaluating a number of approaches in teaching Copperplate to dozens of classes.

You can do Copperplate with your working surface flat or tilted, whichever is more comfortable. Slip guide sheet one under the first sheet in your practice tablet. On the guide sheet are eight pairs of guidelines lettered A through H. The lines at an angle to these guidelines are guides for the slope of the letters and are thirty-five degrees from the vertical. Most formal Copperplate is done at about this slope.

Hold the pen so that the slit of the nib points to the right of an imaginary vertical line (perpendicular to the pairs of guidelines). This may require you to twist the paper at an angle, or to pull your elbow in closer to your body, or to rearrange your chair, or all three. Do whatever is necessary to get the nib aimed to the right of vertical. Seen from above, your pen should look something like this:

You must also consider the angle of the pen to the writing surface. If the pen is too upright, when you apply pressure to spread the nib it will dig into the paper. If the pen is too nearly horizontal, it will be difficult to make very light hairlines. This angle can vary within limits, but seen from the side, it should be somewhere around forty-five degrees.

The Strokes

ALL BUT FOUR of the Copperplate minuscule (small or lower case) letters are made up of seven basic strokes. The more nearly identical these strokes are made each time and in whatever letter they appear, the more accomplished the calligraphy will be. The exercises that follow will present the strokes one at a time to familiarize you with your new writing instrument and to acquaint you with these seven strokes. One final repetition: unless you follow these steps in sequence, you may miss something that will make the difference between your Copperplate's looking amateurish or professional.

STROKE 1. /

It doesn't seem like much, does it? It's only a straight line drawn between two guidelines at an angle of thirty-five degrees from vertical. But there are several things necessary if this line is to be made correctly as a basic stroke of Copperplate letters.

To get the top of the stroke square, pressure must be applied to the nib *before* moving the pen down the paper. Whatever pressure you put on the nib at the start must be maintained until you get to the bottom of the stroke. Keep the pressure on the nib until you have completely stopped; then release the pressure by lifting the pen straight up off the paper slowly.

With these principles in mind (and with guide sheet one still under the first sheet of your practice pad), make a series of stroke 1 between the guidelines lettered A. Make them about one-half inch apart across the paper. Vary the pressure on the nib from stroke to stroke so that you can see the effects of different pressure on the nib. When you've done this, the line will look something like this.

/ / / / / / / / / / / /

Now examine each of the strokes and criticize your work by answering these questions.

Are the tops of the strokes reasonably square? They can look like this / or

even like this / and be correct. If they look like this / , you're starting the stroke

before applying the pressure.

[3]

Are the bottoms of the strokes reasonably square? They can look like this / or

like this / and be correct. If they look like this / , you're releasing the pressure

before the pen stops moving.

Now make a row of stroke 1 between guidelines B. It should look like this:

STROKE 2. ⌐

A new element has been introduced—the hairline that begins this stroke. For this stroke and for all strokes, *all upward movements of the pen are light hairlines.* If you hold up a sheet of paper horizontally by one end, you should be able to make a line on it with your pen. That's all the pressure you should use on any upward movement—as light as possible.

To make stroke 2, start with the pen at the lower of the guidelines in set C. Move the pen up along the slope line about three-quarters of the way toward the top guideline. Start the curve at this point and, after you have gone around the top of the stroke, while still moving the pen, start applying pressure until the line is as wide as your second set of stroke 1 above. Bring the heavy line down the slope and finish it squarely just as you finished stroke 1.

Using guidelines C, make strokes about one-quarter of an inch apart across the paper. Your guideline C should look like this:

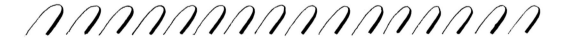

These are the questions to answer as you evaluate each of these strokes:

Is the upstroke too dark? If it looks like this , you're putting too much pressure

on the pen as it moves up the paper. It should look like this:

Is the stroke dark at the top like this ? If so, you're starting to apply pressure

to the nib too soon. Wait until the pen starts the downward movement before putting

pressure on it, so that it looks like this

Is the dark line a uniform width? When you find you're applying the correct pressure, maintain it until you stop the pen movement at the bottom guideline.

Are both the hairline and the dark line of each stroke along the slope? If not, adjust.

The stroke should not look like this or this but like this

Go to guideline pair D and, correcting any errors, make another row of stroke 2, and aim for uniform width of all the dark lines.

STROKE 3.

This is stroke 2 upside down. This stroke starts with a dark line and finishes with a hairline; both lines following the slope except, of course, when they go around the curve at the bottom.

Use guideline pair E and start at the top guideline. Apply the pressure to the nib *before* you begin moving the pen. Move down the slope line, maintaining the pressure until the nib is about one-quarter of the way from the bottom guideline. While the pen is still moving, release the pressure so that as you start around the bottom of the curve there is no pressure

on the nib. Continue around the curve and push a hairline along the slope up to the top guideline.

If your stroke looks like this *U* , you released the pressure too abruptly. If it looks

like this *U* , you didn't have all the pressure off when you started around the bottom

curve. If it looks like this *U* or *U* , you weren't following the slope with the lines.

Your strokes should look like this *U* . Go to guideline pair F and correct any mistakes

you found in your line E.

STROKE 4. *U*

This is a combination of strokes 2 and 3. Using guidelines G, start at the bottom line and push a hairline up the slope to the curve at the top. After you go around the curve, start applying pressure to the nib while the pen is moving. Pull the dark line down the slope. Start releasing the pressure while the pen is moving and the nib is about one-quarter of the distance from the bottom guideline. Go around the curve with no pressure on the nib and push another hairline up the slope to the top line.

Look for the same problems as in strokes 2 and 3. Pay particular attention to the hairlines. Are they made with no pressure on the nib?

Go to guideline pair H. This time make the strokes with about one inch between the finish of one stroke and the beginning of the next. When you have gone across the paper, put a tiny check mark above each stroke. Now turn the paper completely around so that it is upside down and the line of strokes you just finished is at the top of your paper. Between each existing stroke, make another stroke 4. Compare each stroke with the stroke on either side of it. (The check marks will identify the strokes made when the paper was right-side up.) They should be identical. If they aren't, try to figure out why not. Are both hairlines and the dark line along the slope? Did you start applying pressure too soon at the top or keep it on too long at the bottom?

Remove guide sheet one and slide it under the next sheet of paper in your tablet. Try another line of rightside up/upside down stroke 4 in guideline pair A and evaluate them as before.

STROKE 5. *O*

This stroke is an ellipse with its major axis along the slope: *O* It is started about

one-third of the way down on the right side. A hairline is pushed almost vertically and around a top curve to the left. As the pen begins to move downward, pressure is applied to the nib; as the pen begins to move right, the pressure is released until there is none as the nib moves around the bottom of the ellipse. A hairline is pushed to complete the right of the ellipse.

Make a row of stroke 5 in guideline pair B. If it looks like this *O* , it is more nearly

a circle than an ellipse. If it looks like this *O* , it is too narrow. Anything in between

is acceptable. If it looks like this *O* , you began the stroke by pushing to the left

rather than vertically. If it looks like this *O* , you started applying the pressure too

soon. Like this *O* and you kept the pressure on too long. Like this *O* or *O*

and the major axis was not along the slope. Use guideline pair C and do another row of stroke 5. It should look something like this:

O O O O O O O O O O

STROKE 6.

This stroke starts at the bottom guideline. A hairline is pushed up in an arc to a narrow curve at the top and around to the left. Pressure is added while the pen is moving, and a heavy line is pulled down the slope to the bottom guideline. The left edge of the dark line should just touch the beginning hairline at the bottom guideline. Be careful not to start applying pressure on the nib too soon at the top of the curve. Make a row of stroke 6 in guideline pair D.

STROKE 7.

Start this stroke at the top guideline. Apply pressure to the nib and pull a dark stroke down the slope to about one-fifth of the way from the bottom. While the pen is moving, release the pressure and take a hairline around the narrow curve at the bottom and up the arc to the top guideline at the right side of the beginning dark line. Make a row of stroke 7 in guideline pair E. It should look like this:

You have now made at least one row of each of the seven basic strokes of Copperplate calligraphy. One more sheet of practice with the strokes and you can begin putting them together into letters.

Move the guide sheet under a new sheet of paper. In guideline pair B make a row of stroke 2, one inch apart. Turn the paper upside down and make stroke 3 between the strokes you just made.

While you have the paper turned this way, in guideline pair C make a row of stroke 4 one inch apart. Turn the paper back around and, between the strokes you just made, make stroke 4 again.

In guideline pair D make the ellipse, stroke 5. It's hard, so make another row in guideline pair E.

Make stroke 6 about one inch apart in guideline pair F. Turn the paper upside down once more and finish by filling between these strokes with stroke 7.

Leave it. Get up. Move around. Go get a cup of coffee or tea or whatever. Watch a little television, cut the grass, do something different for an hour. Come back later.

You're back. Your eyes, your hands, your back, and your seat are all rested. Refresh your memory with a quick glance at the questions to answer as you evaluate each stroke. Now look at the page of practice you did before you took a break and look at the strokes critically. Are most of them good? Are any of them good? From row to row, are all the dark strokes about the same weight? Move the guide sheet up and do one or two of each stroke somewhere between the rows you completed. Now you're ready for the letters.

Minuscule Letters

THE BASIC STROKES once again are ╱ ╱╲ ∪ ╱∪ ○ ∂ ∂ . They will be used to make up all the letters except *q*, *s*, *x* and *z*.

Though it won't be presented as a separate stroke, you should be aware that all letters—alone, at the beginning of words or anywhere in a word—begin with a lead-in hairline. If it's within a word, that hairline is the finish of the last stroke of the preceding letter. If it's alone or beginning a word, you start the letter by pushing a hairline from the writing line up as though it were the finish of a letter. You will see how this is done as you go through the construction of each letter.

You are going to be using another guide sheet, number two, for practicing the letters. In order to make the instructions easier to follow, the guidelines will have names. If you look at guide sheet two, you will see that it consists of four sets of guidelines. Each set looks like this:

a —— ascender line
—— t & d line
—— waist line
—— writing line
—— descender line

The name for each line is shown to the side. The *a* in each set is there only for reference so that you can easily identify each line.

Now you have a little history, a few principles, seven basic strokes, and a new guide sheet, so you can now begin making letters.

— a —

Stroke 5 + stroke 2

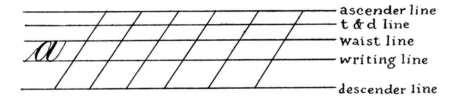

○ plus ∪ equal *a*

Remember, every complete letter has a lead-in hairline.

The lead-in appears to blend with the first stroke at about the midpoint.

The lead-in does not stick into the ellipse like a straw in a watermelon; it blends with it.

this not this not this

this not this not this

The second stroke—stroke 2—is tangential to the first stroke—stroke 5. It does not intersect it.

this not this

At the finish of stroke 5, lift the pen and move up to the waist line and far enough to the right to allow the left side of the nib to pull away from the right side when you add pressure. The left side of stroke 2 just touches the ellipse.

OOPS!

Now try a row of *a*'s and check each stroke of each letter.

— b —

You're only to the second letter and already there's something new. Don't worry, there's very little more.

The lead-in + stroke 6 + stroke 2 + loop

plus plus plus equal

On letters with ascenders, the hairline appears to blend into the ascender at the waist line. By putting a hitch in the movement, the lead-in can be continued as the first stroke—stroke 6—of the letter like this.

Notice that stroke 6 continues into stroke 2. You do not stop before stroke 6 and start stroke 2.

Are strokes sloped properly?

— c —

Lead-in + stroke 5 + a dot

___/___ plus ___𝒞___ plus _____ equal ___𝒞___

Stroke 5 is obviously made a little wider at the bottom to leave the ellipse open.

Note that the ellipse that forms most of the letter has its major axis along the slope.

The dot is made as wide as the dark stroke of the letter. This will be true for dots in any letters—minuscules or majuscules.

The dot is made as though the curve it terminates were continued into a tight spiral—not like a cherry dangling on a twig.

this not this

this not this

—d—

Stroke 5 + stroke 2

o plus *l* equal *d*

Note that stroke 2 starts at the t & d line,
next above the waist line.

Analyze each stroke. See how well you've done. Then analyze how they fit together to form the letter. The second stroke—stroke 2—has its left edge just touching the first stroke—stroke 5.

d *d* *d*

this not this

Even if you realize just what the second stroke is supposed to do, it will take a little practice to get a feel for just the right place to start so that it will just touch but not overlap the first stroke. If a few of them look like

d *d*

this or this

don't worry; you'll get it if you're aware that these are not quite right.

—e—

A hitch + stroke 5

plus *C* equal *e*

The hitch is an almost horizontal movement, begun about midway between the writing and waist lines. It is necessary so that the loop can be made as stroke 5 is made and so the lead-in won't be covered up by the heavy part of the stroke.

not this
The downstroke covers
the lead-in.

not this
The shape is not related to
stroke 5.

this

— f —

Stroke 6 extended to the descender line + a dot + a sideways hairline

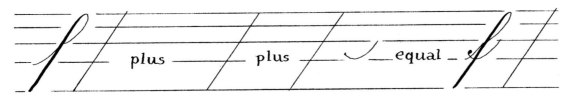

plus plus equal

This is the only letter that is both an ascender and a descender. The dot is just to the
left of the lead-in and about one-quarter of the distance above the writing line to the waist
line. The sideways hairline comes from the dot down to the writing line, through the dark
downstroke, and up along the slope.

— g —

Stroke 5 + stroke 7

plus equal

As with the *a* and *d*, the second stroke is just tangential to the first; don't let it overlap.

not this
The second stroke
overlaps the first.

not this
The finish of stroke
7 crosses too low.

not this
Straw in the water-
melon.

this

— h —

Stroke 6 + stroke 4

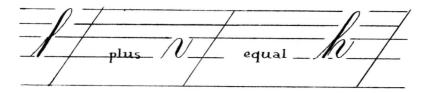

not this
The loop of stroke 6
is too wide.

not this
The hitch was
started below the
waist line.

not this
Stroke 4 does not
follow the slope line.

this

— i —

Stroke 3 + a dot

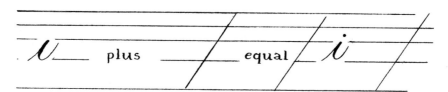

not this
The pen was not lifted
after the lead-in, and the
downstroke covered the
hairline.

not this
The dot should be above
stroke 3 in line with the
slope.

this

— j —

Stroke 7 + a dot

Just as in making *i*, the pen must be lifted and moved to the right after the lead-in is made.

 not this not this not this this

The finish of stroke 7 is too low. The pen was not moved far enough to the right after the lead-in. Stroke 7 does not follow the slope.

— k —

Stroke 6 + a new stroke + a short stroke 4

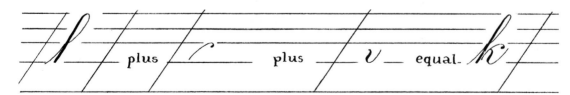

The second stroke—the new stroke—starts just above the writing line and goes up at a steeper angle than the slope. It curves over to the right with the top of the curve just touching the waist line. Finish this new stroke just below the waist line with a dot.

not this

The second stroke is slanted too much.

not this

The second stroke goes above the waist line.

not this

The final dot is dangling like a cherry.

this

—l—

Stroke 6, curved as stroke 3 is at the bottom

equal

Make the hitch at the waist line and watch the slope.

not this

The loop is too wide.

not this

The loop is not wide enough.

not this

The hitch was started below the waist line.

this

—m—

Stroke 2 + stroke 2 + stroke 4

plus plus equal

The second and third strokes start just above the writing line and as near the finish of the previous stroke as possible without touching it. This slight separation keeps the nib from pulling ink out of the wet down stroke. Be careful to make the up portion of the strokes parallel to the dark down portion of the previous stroke. Don't start the curve too soon.

not this	not this	not this	this
The upstroke is not along the slope.	The upstroke was begun in a down-stroke and pulled wet ink.	The upstroke was started too high.	

— n —

Stroke 2 + stroke 4

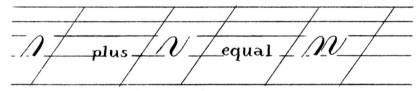

Again, as with the *m*, it's important that the second stroke start slightly above the writing line, as close to the first stroke as possible without touching it, and parallel to it until it curves around the top as stroke 4.

— o —

Stroke 5 + a dot at the join

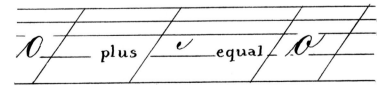

Review your practice on stroke 5 and the instructions for it. Pay particular attention to the starting point. After you make the lead-in hairline, lift the pen from the paper and move it to the right for the beginning of stroke 5. When the stroke joins at the beginning point, continue the pen movement *inside* the stroke in the shape of a dot. Put some pressure

on the down portion of this dot, and it will fill in with wet ink as a solid dot. Be sure to release the pressure immediately at the bottom so the continuation outside the stroke will be a hairline up to the waist line. The key to making a good *o* is having the dot well down on the side of stroke 5 so that the connection to a following letter is graceful.

The *o* may look passable, but it would be difficult to connect it to a succeeding letter.

The dot on the outside of the stroke looks bulky and awkward. Keep the dot *inside* the stroke.

The pen movement necessary for a well-shaped *o* is shown below, first with no shading and then with the proper pen pressure.

pen movement

correct *o*

−p−

Stroke 1 + stroke 4

plus _ equal _

The beginning of stroke 1 should be above the waist line. It can be as high as the t & d line, but it's usually about halfway between the waist line and the t & d line. Pull stroke 1 all the way down to the descender line and finish it cleanly. Lift the pen and start the next stroke just as you did stroke 4 for the *h*, *m*, and *n*—close but not touching the previous stroke and up the slope line. I know, the bottom isn't closed like the *p*'s you've always made, but it is a *p* and it's consistent with the other letters. You'll see it yourself when you start making words with the letters, which won't be too long now.

not this
Stroke 4 should start just above the writing line.

not this
Stroke 1 should begin above the waist line.

this

—q—

Stroke 5 + the q *stroke*

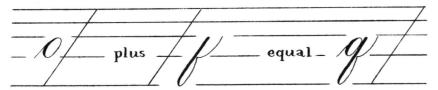

This is the only letter that has the *q* stroke. After you've made stroke 5, lift the pen and move it up to the waist line and slightly to the right, just as though you were going to make an *a*. Carry this stroke below the writing line and start a tight loop to the right that starts back up at the descender line. This loop should not quite touch the heavy down portion of the stroke at the writing line, where it makes a sharp break into the finishing hairline.

—r—

Dot + part of stroke 2

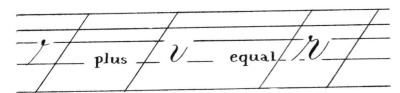

Carry the lead-in hairline slightly above the waist line and make the tight turn in a circular dot, the bottom of the dot resting on the waist line and the continuation of the movement curving slightly below the waist line and right into the top part of stroke 2.

Pressure on the down part of the dot circle should fill it in. If it doesn't, a touch of the nib will. It's easy to make the letter too wide. Take your time making each of the strokes, applying and releasing pressure when you should, and make the width about the same as the width of an *o*. Check that the dot sits above the waist line.

not this	not this	not this	this
Letter is much too wide.	The dot should be above the waist line.	The letter is too thin.	

There is another version of *r* with which you should be familiar. It consists of:
Stroke 2 + a hairline + a dot

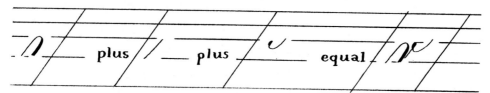

In this version the top of the dot touches the waist line. The hairline is angled just slightly more than the downstroke. Use whichever of the *r*'s you like best. There are advantages and disadvantages to each. More later on this.

not this
The hairline angles too
steeply.

not this
The dot should just touch
the waist line.

this

— S —

An upstroke slightly above the waist line + the s stroke + a dot

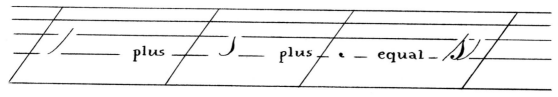

Carry the lead-in hairline just a little above the waist line; lift the pen and let it touch the hairline right at the waist line. Start with no pressure. Move the pen vertically and begin applying pressure as the pen is moving in a slow curve to the left. At about two-thirds of the way down to the writing line the pressure should be at its greatest, and you should begin releasing pressure rapidly as you move the pen in a nearly horizontal curve to the left. Let the bottom of this leftward curve touch the writing line and finish in a dot—a tight spiral continuation of what should now be a hairline. You will have to lift the pen to fill in this dot. Lift the pen and start the finishing hairline from under the second stroke at the writing line. The white space inside the *s* should approximate the space inside an *o*.

not this not this not this

The second stroke is slanted the wrong way, and the letter looks vertical.

The second stroke is sloped too much, and the letter is too thin.

The dot is too high and looks forced and awkward. The bottom of the dot should be on the writing line.

like this

It will take a little practice to make the *s* look right, but once you get it, it's as easy as the others.

— t —

Stroke 3 + a horizontal hairline

plus equal

Begin stroke 3 at the t & d line. Just as you probably do in your everyday writing, it's a good idea to wait until you have finished the word the *t* is in, or perhaps even the next word also, before making the cross stroke. The heavy downstroke will thus have time to dry before you cross it horizontally with a hairline. Make the cross stroke about halfway between the waist line and the t & d line.

this not this or this

Keep the cross stroke short and more to the right than to the left of the downstroke.

this not this and certainly not this

—u—

Stroke 3 + stroke 3

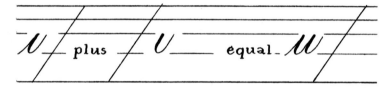

There's not much to say about a *u*. If you can make stroke 3 twice, you've made a *u*.

—v—

Stroke 4 + a loop

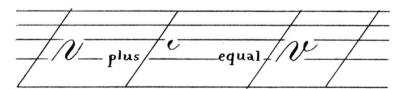

Turn the top of the finish of stroke 4 to the left in the shape of a loop with the top of the loop touching the waist line. You can make the loop a little longer than it is wide so you'll be sure of coming out of the letter with the hairline low enough to make a graceful connection to the next letter.

this not this not this

— W —

Stroke 3 + stroke 3 + loop

𝓊 plus _𝓋_ plus _𝓋_ equal _𝓌_

A *w* is just a *u* with the finish of a *v*. All the cautions about the loop on the *v* apply to the loop on the *w*. Again, you should be aware of the necessity of lifting the pen after you make the hairline on the first stroke 3 and of moving the pen to the right so that the second stroke doesn't cover the hairline.

𝓌

not this

𝓌

this

— X —

Downstroke of stroke 4 made vertically + a dot + the x stroke + a dot

𝓊 plus . plus / plus . equal 𝓍

Make the down part of the first stroke vertically. Make the first dot a tight spiral with its bottom touching the writing line; you'll have to fill in the dot. Continue the hairline up and to the right, and curl the top around in a tight dot spiral with the top of the dot touching the waist line. You made the first stroke nearly vertical so that the axis of the entire letter, the first stroke and the second one combined, would appear to go up the slope line. It's this axis you must keep in mind as you make each of the strokes.

𝓍

First stroke slanted too much; the letter is falling over.

𝓍

First stroke leaning the wrong way; the letter looks vertical.

𝓍

First stroke is good, but the second one started too close.

Again, look at the axis of both strokes combined. 𝓍

— y —

Stroke 4 + stroke 7

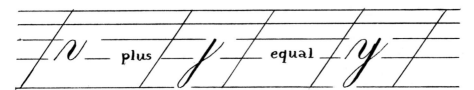

After you have made stroke 4, lift the pen and move it a little to the right at the waist line so you don't have stroke 7 covering the hairline portion of the first stroke.

not this	not this	this
The second stroke **was** started too close **to the first.**	The upward hairline of stroke 7 crosses too low.	

— z —

Top z stroke + bottom z stroke

Start as you would for stroke 2. After you go around the top at the waist line, keep the downstroke in a gentle curve to the left until the pen is almost at the writing line. Then make a tight loop and continue around to a longer curve, down the slope line as an axis, and around at the bottom as in stroke 7. The upward hairline, however, will cross the downward portion just below the writing line. Again,

Work on it. Fortunately you won't have to make very many *z*'s.

MINUSCULE READY REFERENCE SHEET

The following page shows each minuscule letter with the component strokes separated and then combined into the letter. This one-page presentation of the letters is intended for your reference as you begin the exercises using the letters in words and sentences. However, you should go back to the detailed explanation of the letters as you review your work.

Minuscule Ready Reference Sheet

ı o ʋ = *a*	ı l = *l*
) l c = *b*	ʌ ʌ ʋ = *m*
ı ° c = *c*	ʌ ʋ = *n*
ı o l = *d*	ı c ʋ = *o*
ʌ c = *e*	ı / ʋ = *p*
) / ʋ = *f*	ı o f = *q*
ı o f = *g*	ı ʋ = *r*
) / ʋ = *h*	/ ɹ ₀ / = *s*
ı ʋ · = *i*	ı l ¯ = *t*
ı ʄ · = *j*	ı ʋ ʋ = *u*
) / ʋ = *k*	ʌ c = *v*
	ı ʋ ʋ c = *w*
	ʌ ɹ = *x*
	ʌ ʄ = *y*
ɹ ʄ c = *z*	

EXERCISE ONE

Larger letters will be required for this exercise to fill the guidelines which are provided on guide sheet three. You should use your most flexible nib—a Gillott 303 or Brause EF 66, or their equivalent—and apply enough pressure to create a downstroke wide enough to relate well to the height of these letters.

This increased height and weight will make it much easier to spot any mistakes and also permit you to see readily just what efforts of pressure on the nib have on the shape of letters.

Place guide sheet three under a new page in your practice pad. Begin the exercise by making two or three of each stroke across the set of guidelines marked A to get a feel for their height and weight. Your first line may look about like this:

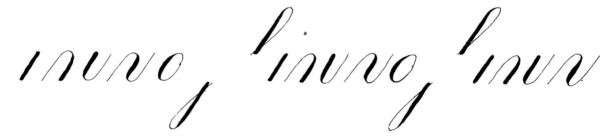

Now put the strokes together into letters at this increased size. Just go through the alphabet, trying to keep the weight of the downstrokes of all letters consistent. Use guideline sets B, C, and D for this part of the exercise.

Now analyze the letters you've just made, using the detailed instructions for each letter from the previous section. You guessed it; check first for the slope. Do so by getting back about eight or ten feet from your paper and looking at the entire sheet at once. See which letters obviously have the wrong slope. Then go through the instructions for each letter and analyze yours, making notes on your sheet as you go. Now use guideline set E to correct any errors. Use a new sheet of paper if you need to.

EXERCISE TWO

Now you are going to make words. Finally, you say. Well, it will pay off to have approached it systematically. Use guide sheet three for this exercise.

Using guideline set A with a new sheet of paper, write the words "pack my box with five." Make each stroke of each letter carefully. Leave the space required for a letter *o* between words.

Use guideline set B to write "dozen liquor jugs." Now you have used all twenty-six letters in a sentence. Just as in exercise one, stand back from the paper and look at the entire thing. Put it alongside the exercise two example, which follows. Try to determine how yours differs from the example. Slope? Letter shapes?

Exercise Two Example

pack my box with five

dozen liquor jugs

EXERCISE THREE

The hitch in the upstroke for the ascender letters—*b*, *f*, *h*, *k*, *l*—and for the *e* is there so that the downstroke doesn't cover the lead-in hairline. However, when these letters are made following a letter that has a loop or dot on the side—*b*, *o*, *v*, *w*, or the alternative *r*—the hitch isn't necessary. The finishing stroke out of these letters doesn't start at the writing line, so there's nothing there to cover with the downstroke. Just adjust the finish from the dots or loops to fit an ascender or the *e*.

Use guide sheet three and write each of these sets of words across a pair of guidelines:

berry often whistle
observe brag very
crawl kerf lofty
over wharf awkward
cork westerly carbon

Compare your work with the example and note the differences. Use another sheet to make corrected versions. Use different words with these letter combinations.

Exercise Three Example

berry often whistle

observe brag very

crawl kerf lofty

over wharf awkward

cork westerly carbon

Majuscule Letters

ALTHOUGH THERE IS ONE STROKE which is common to thirteen of the letters, the rest of the letter shapes are too dissimilar to be approached on a stroke-by-stroke composition as the minuscules were. Therefore, after practicing the one stroke, the letters will be looked at and learned on a letter-by-letter basis.

In flexible-pen calligraphy, a stroke which starts thin, gets thick, and ends thin, is often called a "swelled" stroke. The one stroke common to half the capitals is a swelled stroke, and it is, appropriately enough, referred to as the "cap" stroke.

It is made by starting at the ascender line with no pressure, moving along the slope, adding pressure until the width you have selected for your writing is achieved at the waist line. While the pen is still moving, pressure is released until it is all off at about one-third of the distance above the writing line, and the pen is moved in a graceful curve to the left.

It sounds much more complicated than it is. This is the way it looks.

You can start it with a very gentle curve, but for most of its length before the bottom curve, the pen is moved straight down the slope. Most of the appearance of a curve is brought about by the nib's separating and closing as pressure is added and released. The bottom of the stroke is pulled out to the left—probably more than you think at first glance. Curl it back up just enough to raise it very slightly above the writing line.

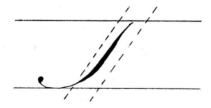

It finishes with a dot curled back into the stroke, and the dot is the same diameter as the widest part of the downstroke. That's true of all dots in both minuscule and majuscule letters. Using guide sheet two, make a line of the cap strokes. Start them farther apart than you might think necessary—about an inch between starting points—so that you'll have plenty of room to pull the bottom of each stroke well around to your left as you finish it. Look at your strokes closely and see if yours have any of the common problems illustrated below.

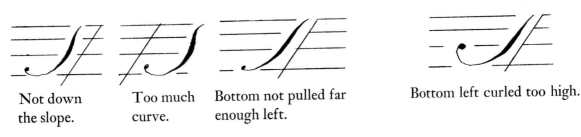

Not down Too much Bottom not pulled far Bottom left curled too high.
the slope. curve. enough left.

Now try to correct these problems as you do another line of the cap stroke. That's enough. It might not be exactly right yet, but it will get easier when you use it as part of a letter.

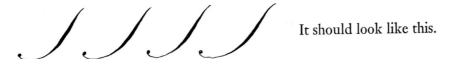

It should look like this.

Now to the letters. The basic principles that applied to the minuscules also apply to the majuscules. All downstrokes are heavy; all upstrokes are light. The axis of the letter as a whole is down the slope. This matter of slope is a little more subtle for the capitals than for the minuscules, but it will become apparent that many of the components of the letters must be related to the slope if the letter as a whole is to bear the proper slant.

Now we're going to get into the essentials of majuscule letters in the Copperplate alphabet. The slope, the appearance of the *entire* letter, is a major factor. The cap stroke, as you have already practiced, goes down the slope line; but few other strokes follow the slope line. It's the slope of the letter that you must consider. And now comes a most difficult notion. As you're doing most majuscules, you must think *ellipse*. The elliptical shape is a part of many majuscules: some obvious and almost complete ellipses; some only parts. But you've got to have an ellipse pictured in your mind as you're making these letters.

Some big ones ⬭ , some fat ⬭ , some thin ⬭ , some

small ones ⬭ , but all ellipses.

Just look at the majuscule *B*

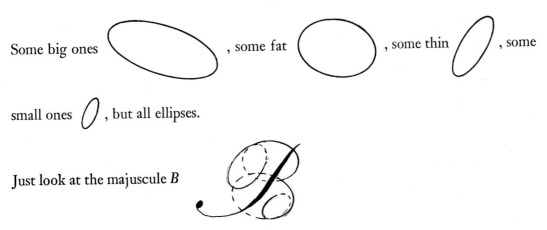

Don't let all those dotted lines scare you. The relation of most of these ellipses isn't an absolute that you have to memorize. The main thing is that you think *slope* and think *ellipse* as you're making these letters. It's easier than it looks. Now, after the *A*, we'll get back to letters with this principle of the ellipse.

After you have read the description of each majuscule, try at least one line of each and then analyze them, using the description as a guide.

—A—

This stroke is shaped like the cap stroke but in the *up* direction and slanted just a little more than the cap stroke. Start just above the writing line.

This downstroke begins with no pressure at the point where the first stroke finished. Pressure is added rapidly and maintained to a squared-off finish at the writing line. This stroke is slanted *less* than the slope line.

The pen is lifted and the third stroke is begun just above the writing line and as close to the second stroke as you can get without touching it. This stroke is pushed up and to the left across the first stroke and curved down, back around to the right. Add pressure as the stroke starts downward and release it as it moves right and up.

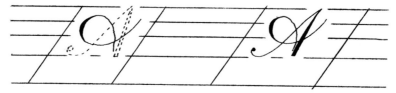

Make a line of *A*'s. Examine and analyze them.

Letter is too upright because first stroke was not slanted enough.

Strokes slanted too much, and letter is tilted.

Second stroke started with pressure. Wait until the pen is moving before applying pressure.

—B—

A cap stroke and the parts of four ellipses

After you make the cap stroke down the slope line, start a small ellipse at about one-fourth of the letter height below the ascender line. The major axis of this ellipse should be the slope line.

Start the stroke with no pressure, add pressure as you go around the right side of the ellipse and begin releasing it as the curve starts left. Have no pressure as you go around the bottom and up the left side of this ellipse. As you near the ascender line, you have to think of the larger second ellipse.

The second ellipse continues out of the first. Keep it at hairline as it goes around the top and don't apply pressure until after it has crossed the cap stroke and starts moving down. Release the pressure as the stroke starts left, and carry the hairline to just short of the cap stroke. Make a small loop with its left side not quite touching the cap stroke, and out of that loop go into the larger third ellipse which forms the lower bowl of the *B*.

This ellipse extends to the right just a little more than ellipse two of the top bowl. As the bottom of this ellipse touches the writing line, start it back up into the last ellipse, which will show only a portion of its left, hairline side.

Try it. Think slope. Think ellipse. This is one of the hardest majuscules, so if you get it, you won't have much difficulty with the others.

—C—

The *C* consists of portions of three different ellipses.

Start the first ellipse just above the ascender line, *without pressure.* As soon as the pen starts moving, begin adding pressure until the curve starts moving to the right. Release all pressure at the point where the curve is moving horizontally. Continue this first ellipse up to the ascender line and let it go into the large ellipse. Look at the points of maximum and minimum pressure. After the large ellipse starts up the right side, turn it over the top into the final ellipse. *Release all pressure* before you finish the last stroke and the letter will have a more finished, graceful appearance.

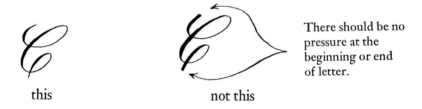

There should be no pressure at the beginning or end of letter.

this not this

—D—

This is usually considered to be the most difficult letter, majuscule or miniscule, in the Copperplate alphabet. And with good reason. It requires a great deal of pen pushing in awkward directions. It begins simply enough with a cap stroke.

At the finish of the cap stroke, turn back to the right in a long loop.

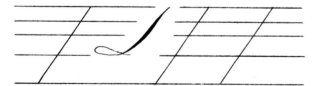

And now comes the harder part. Push a long curve up, generally along the slope line and closer to the cap stroke than you might think, until about two-thirds of the way up it moves to the left across the cap stroke at a point below the ascender line.

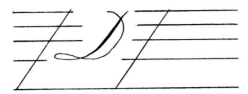

When this stroke touches the ascender line, turn it down into an ellipse.

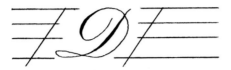

You will probably feel that this *D* is too thin. So you, as most students of Copperplate do at one time or another, will try it a little wider. Do. I have, many times. With the wider *D*, the problem is that the entire letter has the wrong slope. Experiment and if you find a solution that works, use it.

—E—

Ellipses and ellipses.

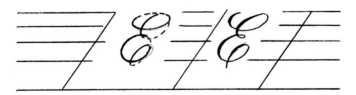

Move out of one ellipse into the next gracefully, always remembering to put pressure on the downstrokes and to release it for all others. As with the *C*, the letter will look more graceful and finished if you begin and end without any pressure.

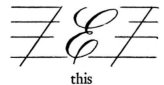

this

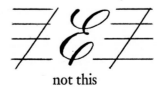

not this

—F—

A cap stroke, an ellipse, a horizontal wave and a cross stroke

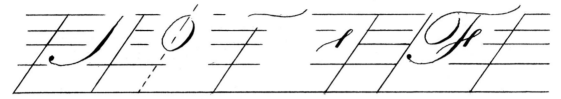

The major axis of the beginning ellipse should be along the slope line.

The highest point of the horizontal top wave is on a line with that axis, and the wave is very gentle and slight, not a deep trough.

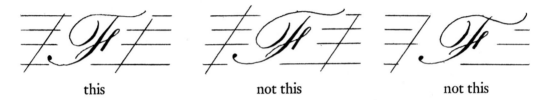

 this not this not this

—G—

Two ellipses, a sweep, a loop, and a cap stroke

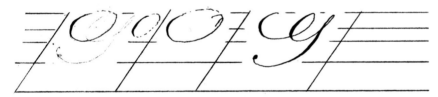

Think ellipse. Think slope. Just to make it look a little more like the G you're used to, you can curl the final part of the cap stroke up more than you do for most other letters.

You might want to try an alternative G with a descender.

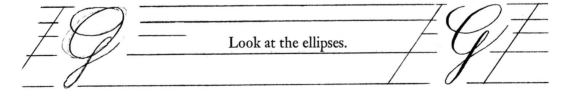

Look at the ellipses.

−H−

A lead-in, a cap stroke, a cross stroke, and a flat-sided *C*.

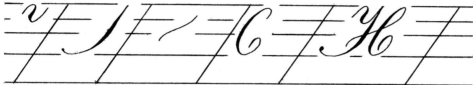

Make the dark downstroke of the lead-in down the slope line. Make the cap stroke down the slope line. Make the nearly flat long side of the *C* down the slope line. Finish the last stroke with no pressure. This letter seems to look a little better if the right side of it is just a little higher than the left, so begin the cap stroke at the ascender line and carry the beginning of the right side just slightly above the ascender line.

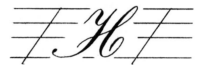

−I−

A cap stroke, a tiny top loop, and a left side-stroke

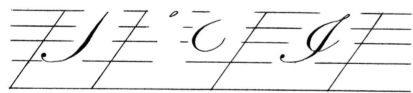

A left side-stroke? Well, I didn't know what else to call it. It starts out of the little loop you make at the top of the cap stroke. You'll use it again in the *J*, so it needs some name.

−J−

A long stroke down the slope line, the bottom of minuscule stroke 7, a tiny top loop, and the left side-stroke

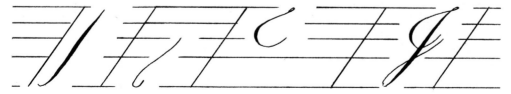

There isn't much to be said about or for a *J*. Start the long initial stroke with no pressure, adding pressure as you move down the slope line until you begin releasing it for minuscule stroke 7.

–K–

The *K* begins with the same lead-in stroke used for the *H*, the cap stroke, and the right side-strokes.

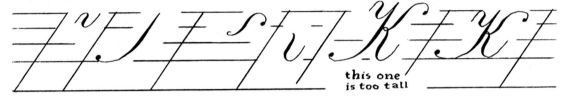

Start the right side with a dot slightly below the ascender line. Curve out of the dot up to the ascender line and down to a loop at about mid-height. The loop should just barely touch the cap stroke or even just miss touching it. The lower-right side comes out of the loop to complete the right side.

–L–

A long horizontal ellipse, plus the cap stroke, plus a loop, plus a bottom wave

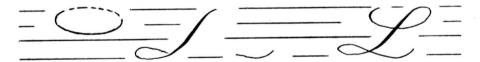

Be sure to carry the cap stroke far enough to the left to make a generous loop. Keep the bottom wave-stroke short so as not to distort the slope of the letter. However, you can drop it below the writing line in order to set the following minuscule over this bottom stroke to keep spacing consistent.

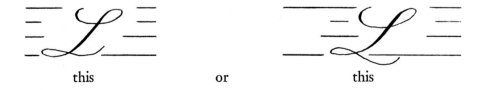

this or this

— M —

The slope of the legs of the *M* can best be shown by first looking at a skeleton letter of the classic Roman shape.

 As you can see, the legs are splayed slightly. Now, if we take this square and push it over to the right so the vertical sides are at the thirty-five-degree slope of our Copperplate letters, it will look like this.

So, for the Copperplate *M*, the left leg is inclined a little more than the slope line, and the right leg a little less.

Begin the *M* with a dot above the writing line. The short horizontal sweep comes out of the dot and up, forming the left leg with the increased slope as just described. Then comes the left side of the middle *V*. This, because it's almost vertical, is much shorter than most majuscule strokes. It starts with no pressure, goes to full pressure, and back to no pressure in a very short distance. Make a tight curve at the writing line and back up, making a very gentle curve for the right side of the middle *V*. The final stroke, the right side, is a little more vertical than the slope line, as described above.

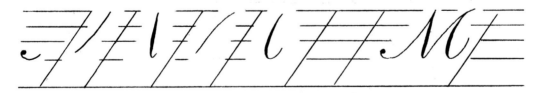

— N —

The legs of the *N*, if put in the Roman square which was used to describe the *M*, would be vertical. Therefore, when the square is tilted thirty-five degrees, the legs of the *N* will also be at thirty-five degrees. So make sure the legs of the *N* go along the slope line. The first and second strokes, except for the slope, are just like those of the *M*. The right leg goes up the slope line and finishes in a curve with a final dot.

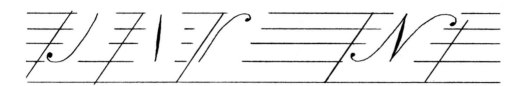

It is essential that the second stroke be started and ended with no pressure so that there are sharp points at the intersection with the first and third strokes.

this

not this

−O−

The *O* is essentially a long, rather fat ellipse, with its major axis along the slope line.

−P−

The cap stroke plus the top of a *B*

You must be getting tired of reading it; I'm getting tired writing it; but once again—the major axis of the beginning ellipse is *along the slope line.*

−Q−

Large ellipses, a loop, and bottom stroke like the *L*

Both ellipses have their major axes along the slope line. If you think I'm harping on attention to the slope, you're right.

−R−

The cap stroke, the top of a *B*, and the bottom right of a *K*

Just as they do with the *D*, most students feel that the bottom of the *R* is too narrow. So try it other ways. You should keep in mind that rarely will you have occasion to make a Copperplate majuscule all by itself. Most of the time it will be followed by minuscules. So, however you make it, it will have to blend harmoniously with those minuscules.

−S−

A dot, a diagonal upsweep, a loop, and a cap stroke

As with the *G*, you may want to curve the cap stroke around to make the letter more like the *S* you are accustomed to.

−T−

The cap stroke, an ellipse, and a horizontal wave

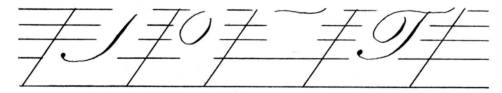

Don't carry the top horizontal wave too much to the right. As you can see, it's just like the *F* without the cross stroke. And all the cautions on the *F* apply to the *T*.

−U−

An ellipse, large versions of minuscule strokes 4 and 3

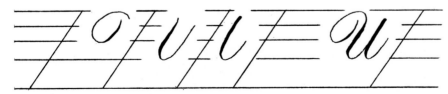

In this one the axis of the ellipse and both succeeding strokes are all down the slope line.

— V —

The lead-in used in *H* and *K*, and two strokes similar to the second and third strokes of an *N*, but at different slopes

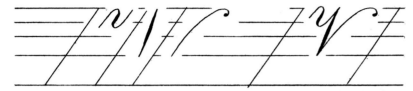

Start and end the second stroke with no pressure so that there are good sharp points top and bottom.

— W —

Two *V*'s

Try to get both dark downstrokes alike in shape, weight and slope.

— X —

Four ellipses which somewhat resemble two *C*'s back-to-back

Make the heavy parts of the two large ellipses overlap *exactly*. If they just touch, there will be an abnormally wide black area where they meet. You may have to wait for the left side to dry thoroughly before you make the right.

— Y —

An ellipse, large versions of minuscule strokes 4 and 7

Or you may prefer a version without the descender. If so, substitute a shorter stroke 4 and a cap stroke for stroke 7.

— Z —

Three ellipses and the finish to minuscule stroke 7

Now you've been through the minuscules and the majuscules of the Copperplate alphabet. I have never had occasion to do a word in all majuscules, nor do I think the few I have seen are legible or attractive.

So, in the following exercises, you will be asked to practice the majuscules in combination with minuscules. This is the only way you can get a feel for all the emphasis I've been putting on both slope and consistency.

MAJUSCULE READY REFERENCE SHEET

Just as with the ready reference sheet for minuscules, the following page is a presentation of each majuscule letter. Use it as a reference as you practice the various exercises, but go back to the instructions for individual letters as you examine your work.

Copperplate Calligraphy

Majuscule Ready Reference Sheet

A B C D E F

G H I J K L

M N O P Q R

S T U V W

X Y Y Z

EXERCISE ONE

Use guide sheet three. With the majuscule ready reference sheet at hand, make two of each letter. Of course you will be aware of the slope (are you sick of that word yet?). But try different weights on the downstrokes.

Compare yours with the following page. Which weight downstroke do you like best? Analyze your best letter from each set, using the detailed instructions as a guide. After you've determined what corrections need to be made, make another page of the majuscules.

Exercise One Example

A A B B C C D D E E

F F G G H H I I J J

K K L L M M N N O O

P P Q Q R R S T T U U

V V W W X X Y Y Z Z

EXERCISE TWO

Use guide sheet two.

You will seldom, if ever, have occasion to write a word in all majuscules. This exercise is designed to give you an opportunity to practice each majuscule in combination with the minuscules.

Go through the alphabet, writing a name beginning with each letter. For instance, you might start by using Albert, Bertha, Charles, Dianne, Elizabeth, and so on. Try to select names that will use all the minuscules.

The following pages are examples of the names that could be used for this exercise and how the completed exercise might look.

Exercise Two Example

Albert Bertha Charles

Dianne Elizabeth Fred

George Heather Inez Jessie

Katherine Louis Marsha Nora

Ophelia Patricia Quincy

Raymond Susan Theresa

Ursula Victor Wallace

Xavier Yolanda

Zeus

Numbers

OUR NUMBERS EVOLVED from a different source than our letters, as you are aware. We even refer to them as Arabic numerals to distinguish them from the Roman numerals, which have an ancestry in common with our letters. As a consequence of the different sources, the shapes of the numbers don't relate very well to any western calligraphic alphabet, so we do whatever we can to make them harmonize with the letters while making sure they are still readable.

A stroke-by-stroke analysis and presentation is not necessary. The strokes are obvious as you analyze the numbers that follow. You can see that there are some exaggerated waves in what are generally horizontal strokes in order to get some weight on the down portion of the wave and into the stroke. This is most apparent in the bottom of the 2 and the top of the 7.

Look at each letter carefully and observe the strokes; also notice how the numbers do and do not harmonize with the letters.

A few punctuation marks and symbols are also included in this example. I hesitate to say it again, but I must—note the relation of all numbers and symbols to the *slope line*.

NUMBERS

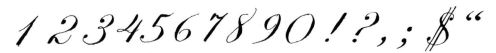

The only way to make the top of the 5 dark—and it almost has to be—is to make two lines and fill them in. The only alternative is to turn the paper or the pen sideways to make the top as a downstroke. I recommend the two-line method.

The o, 6, and 9 need weight on both sides so they are made from two separate, connected strokes. Try leaving them as hairlines and they just don't look right.

$$O \quad 6 \quad 9 \qquad O \quad 6 \quad 9$$

Numbers never need lead-in hairlines. Oh, what a relief!

Comprehensive Exercises

EXERCISE ONE

Use guide sheet two.

Use each month and write a date. Be sure to use all ten digits.

The completed exercise should look like the examples that follow. As with all the exercises, you should examine your work critically, both in comparison with the example provided and on a letter-by-letter basis.

Exercise One Example

January 27, 1930

February 17, 1938

March 15, 1843 April 26, 1938

May 30, 1762 June 28, 1932

July 5, 1967 August 24, 1884

September 30, 1957

October 26, 1964

November 18, 1673

December 25, Everyyear

EXERCISE TWO

Use guide sheet five. This guide sheet is the same size as guide sheet two, but the descender line of one set of guidelines is the ascender line for the next set of guidelines below it. This is the way you would use guidelines in writing out a quotation or address.

For this exercise, write out addresses using a different majuscule each time for the name of the city. Make sure you use all the digits and all minuscules as well.

You might begin with something like:

Mr. and Mrs. Albert Broadstreet
987 Cherry Street
Atlanta, Georgia 65432

Miss Betty Christopher
1376 Duquesne Avenue
Baltimore, Maryland 24580

Note in writing Mrs. that if you use the alternate *r*, the left side of the *s* is left open. The first *r* gives a nicer appearance. If for no other reason than that there is a following *s*, which happens often, I prefer to use the first *r*.

Exercise Two Example

Mr. and Mrs. Albert Broadstreet

987 Cherry Street

Atlanta, Georgia 65432

Miss Betty Christopher

1376 Duquesne Avenue

Baltimore, Maryland 24580

Mr. and Mrs. Curtis Dowd

435 Eagles Nest Road

Casper, Wyoming 68719

EXERCISE THREE

The guide sheets you have been using so far are for letters larger than you would normally use. The exception is perhaps guide sheet two, but it is at about the outside limit. They were purposefully made large to allow you to identify your errors more readily.

For this exercise, use guide sheet four, which is for considerably smaller letters. Write the following quotation:

> They have in general a bad notion of their neighbouring province, Maryland, esteeming the people a sett of cunning sharpers; but my notion of the affair is that the Pennsylvanians are not a whit inferior to them in the science of chicane, only their method of tricking is different. A Pennsylvanian will tell a lye with a sanctified, solemn face; a Marylander, perhaps, will convey his fib in a volley of oaths; but the effect and point in view is the same tho' the manner of operating be different.
>
> Dr. Alexander Hamilton
> Itenararium, 1744

Compare it with the example. Notice particularly the slope and consistency of weight in the downstrokes.

Exercise Three Example

They have in general a bad notion of their neighbouring province, Maryland, esteeming the people a sett of cunning sharpers; but my notion of the affair is that the Pennsylvanians are not a whit inferior to them in the science of chicane; only their method of tricking is different. A Pennsylvanian will tell a lye with a sanctified solemn face; a Marylander, perhaps, will convey his fib in a volley of oaths; but the effect and point in view is the same tho' the manner of operating be different.

Dr. Alexander Hamilton
Itenararium, 1744

Additional Hints

Up to this point you have been practicing Copperplate as a calligraphic alphabet, making each letter as nearly like the instructions and examples as you can. At least that's what I hope you've been doing. For the most part, that's what I hope you continue to do.

There are, however, reasons for departing from the letter forms as I have presented them in this book, and I want you to understand them. But most of all, I would like you to be aware that they are departures, and if you choose to do so, to know why you are departing.

There is a principle that applies to calligraphy, broad pen or flexible pen, that every calligrapher should understand and use. This principle has been phrased many ways, but perhaps the simplest is best: the page is more important than the line; the line is more important than the word; the word is more important than the letter.

The importance of this principle will probably come to your attention first when you begin a sentence with the word *The*. If you make both the *T* and the *h* just as the instructions read, then the ascender of the *h* is going to touch or overlap the horizontal wave at the top of the *T*. So, to make the word look good, you should either raise the cross of the *T* or shorten the ascender of the *h*. Either way, if done just enough to avoid touching, the alteration will improve the word and not seriously affect the appearance of the letters. You will encounter other cases where a letter must be modified for the appearance of the word.

This principle will often be your guide in deciding whether to use an abbreviation. Will the full word or the abbreviation make the line look better? You may have to shorten or lengthen the bottom pull to the left of a cap stroke to slightly shorten or lengthen the line.

Particularly in a short piece—three to five lines—you will occasionally have a line that has no descenders. In order for the page to look good, and not have too much white space between those lines, you may want to raise the line under the one with no descenders just slightly.

The page is more important than the line. The line is more important than the word. The word is more important than the letter. Keep this hierarchy in mind as you do any kind of calligraphy.

Another departure from the letters as they are presented is warranted simply as a matter of choice or opinion.

Now that you are familiar with Copperplate, you will become more sensitive to the examples of it you encounter in books, exhibitions, advertising, or anywhere else. You may find a form of letter that you like better than the one I have given you. If so, by all means adopt it for your Copperplate calligraphy. Be sure that you consider overall appearance when you use it, primarily in terms of its relationship to all the other letters. A good case would be ascenders without loops. You will see many good examples of these variants. Try them, and if you prefer ascenders without loops, make yours that way.

Finally, the only way to learn calligraphy is by doing calligraphy. I think it was Edward Johnston who said that all you learn by practicing is how to practice. Whoever said it, it's pertinent. Do it. Pick an appropriate quotation and make up your mind to do it as a finished, frameable piece. Of course you will make mistakes. Sure, you won't be satisfied with each letter. But you will be learning *calligraphy*.

Some Examples

THESE EXAMPLES ARE SLIGHTLY FLOURISHED majuscules copied from a nineteenth-century French book *Embellishments and Transformation* by Jules Girault (Paris, 1867) printed from engraved plates. You need to be very careful in attempting to flourish Copperplate, as the results are all too often garish and ridiculous rather than graceful and beautiful.

If you will look carefully at any individual letter in this example and picture it as an isolated majuscule in an ordinary context with minuscules, you will see what I mean. Better still, pick two of these majuscules, practice them until you're comfortable with them, and then use them as the capitals in a name. Now do the same name with your regular majuscules and see which is more dignified.

There is a misleading feature about seeing flourished letters on an impressive page and trying to copy them for use in another context: the flourishes on those letters were done for that particular context and are compatible with other flourishes on that page. Taken in isolation, the letters are not so nice.

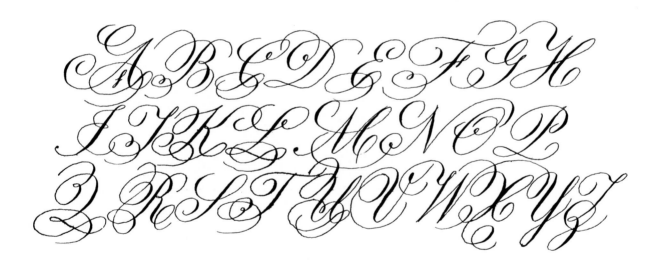

The examples that follow are taken from R. Langford's small (three-inch-by-eight-inch) book, *Text Copies* (London: J. Chappell, 1839). Although some of the extremely fine hairlines get lost in the reproduction process, you can still get a good impression of a graceful, relatively unflourished set of majuscules as well as some slightly different minuscules.

Knowledge polishes nature.

Learning requires application.

Maintain liberal principles.

Small Hand Copies Set 19.

Written **By R. LANGFORD,** *Haydon Sq. London.*

A B C D E F G H I J K L M

N O P Q R S T U V W X Y Z

1 2 3 4 5 6 7 8 9 0.

London. Published Stationer & Bookseller,
Jan.^y 1st 1839 by J. Chappell. 146, Minories.

Book-keeping-Methodised 4/. A set of Books ruled to correspond 7

... our Heroe, Captain Thatch, assumed the Cognomen of **Black-Beard**, from that large quantity of Hair, which like a frightful Meteor, covered his whole Face, and frightn'd America, more than any Comet that has appear'd there a long time.

This beard was black, which he suffered to grow of an extravagant Length; as to Breadth, it came up to his Eyes; he was accustomed to twist it with Ribbons, in small Tails, after the manner of our Ramellies Wigs, and turn them about his Ears ... his Eyes naturally looking Fierce and Wild, made him altogether such a Figure, that Imagination cannot form an Idea of a Fury, from Hell, to look more frightful.

Captain Charles Johnson
1724

Many people erroneously use the term "Spencerian" to describe Copperplate calligraphy. The example that follows shows just how wrong that is. The example is taken from one of my favorite books, *Real Pen Work Self-Instructor in Penmanship* (Pittsfield: The Real Pen Work Publishing Co., 1884). It is guilty of anything but modesty by the publishers. The first two paragraphs are short enough to quote, and they give an indication of just how self-effacing the company wasn't.

> This Book, The Real Pen-Work Self-Instructor in Penmanship is the largest, and by far the best and most elegantly illustrated work ever published on the subject of penmanship.
>
> The Real Pen-Work Self-Instructor in Penmanship is universally acknowledged by expert penmen, writing teachers in business colleges, and by men of learning and the best judges everywhere, to be the *greatest means ever known for learning to write an elegant hand;* everybody, everywhere, all acknowledge this work to be the greatest means ever known for learning to do pen-drawing and flourishing and all kinds of the most beautiful ornamental pen-work.

The book continues in the same subdued manner throughout. One final quote. "Even the dullest scholar can learn to write well from this method in a very short time."

SPENCERIAN SCRIPT.

P Pindar Q Quarts R Richard

S Sundry T Trenton U United

V Virgits W Weights X Xingu

Y Yazoo Z Zachary & Company

Albany N. Y. Boston. Mass. Canton. O.

REMARKS.—This page and the preceding page are specimens of *real written* copies, by Spencerian Authors, who are known the world over as the best writers that lived. These very pages are the best written pages in the world. They are the best specimens of elegant writing ever done with a pen. These two pages are taken permission from the New Spencerian Compendium of Penmanship, published in five parts, by Ivison, Blakeman, Taylor & Co., New York. The New Spencerian Compendium illustrates to perfection the great skill of the Spencers, and the immense value of their system. Copyrighted 1880, by Ivison, Blakeman, Taylor & Co.

Most of the Copperplate pen men took great pride in their "off-hand" flourishing of garish figures. A favorite subject was birds, of no recognizable species usually, but the subjects included everything from St. George slaying the dragon to quills. The heads in the next example are fairly representative of the art. The term "off-hand" meant exactly that: No part of the hand came into contact with the paper as the figure was being executed with the pen, which was held in a position completely different from the writing grip. Many of the pen men contended that their flourished pictures were made without lifting the pen from the paper. They never did explain how they got their pen to hold enough ink to practically cover a large sheet of paper with shaded lines without redipping.

Undoubtedly the best-known book of Copperplate calligraphy is George Bickham's *The Universal Penman* (London, 1733–1741). Facsimile editions of this book have been printed by Dover Press and are available at a very reasonable price. The following pages are examples from that famous book. I have selected pages that seemed to make interesting reading as well as to give some idea of the various subtle differences in style of three of the twenty-five calligraphers represented in the book.

Dr. Mr. Simeon Young's Accot. Currt. Cr.

		Liv. Sol. Dn.
1740.		
March 31.	To Cost & Charges of 10 Pa. Brandy pthe James..	1290.6.5
Apl. 7	To Do. of 20 Pa. Prunes & 2 Tun Wine pthe Jane..	732..5.-
	To my Bill of 72 C: 5 Sol. remitted him	
	on Mr. Jonathan Robinson..........	216..5.-
June 16	To Postage of Letters to this Day	1.15.-
	To Ballance transferd to yr. Credit in new Accot....	49..-.7
		2289.12.-

		Liv. Sol. Dn.
1740.		
Mar. 31	By my Bill on him in favour of	
	Mr. Francis Amots. of 315 C: 12 Sol...	945.12.-
May 15	By his Remittance at 10 days sight	
	of 266 Cr. on Mess. Power & Jean Larom.	798..-.-
19	By his Remittance at 8 days sight of	
	182 Cr. on Mr. James Sims of Rochel...	546..-.-
		2289.12.-

Bourdeaux, June 20. 1740. Errors excepted.

Leond. Barjeau.

E. Austin Scrip.

These are to Certifie whom it may Concern that the bearer hereof George Froy Served five Years in Quality of Gunners Mate on Board his Majesty's Ships the Cumberland & Dartmouth both under my Command, during which time he behaved Soberly Diligently and Obedient to Command. And I recommend him as deserving Encouragement. Given under my hand on Board his Majesty's Ship the Cumberland this 12 day of October, 1739.

Brown

To the Right Honourable the Lords Commissioners of the Admiralty.

We whose Names are hereunder Written Gunners, in his Majesty's Royal Navy, do hereby Certifie that George Froy performed the Several Heads of Examination appointed by Your Lordships to Qualify him for a Gunner on the 12 of November, 1739. And we do believe him capable to Serve as Gunner on Board any of his Majesty's fourth Rate Ships. Given under our hands on Board the Namure this 14 day of November, 1739.

J. Longman		Namure
W. Salter	Gunner	Cornwall
J. Thomas	of the	Grafton
Geo. Hind		Cumberland

Dove, for.

A
Letter from a Servant in London,
To his Master in the Country

Sir,

As I find You are detain'd longer in the Country than You expected, I thought it my Duty to acquaint You that we are all well at Home, and to assure You, that Your Business shall be carried on with the same Care and Fidelity as if You were personally present. We all wish for Your Return, as soon as Your Affairs will permit; and, it is with pleasure, that I take this Opportunity of Subscribing my Self.

Cheapside
24 June 1740.

Sr
Yor. Faithful Servant,
Sam. Trusty.

E. AUSTIN SCRIPSIT.

A

Young Gentleman's

Letter, to his Father.

Hon.d Sir, June 27.th 1740.

This is the sixth Letter I have sent you by
divers Ships, since Michaelmas last; which are I hope, all come
safe to hand. I have nothing new or particular to communicate,
only beg you would conceive so favourable an opinion of me, as
to believe I prosecute my Studies with the utmost application;
well knowing, that will prove the best recommendation to your
favour at present, and most real Service to my self in time to
come. All our Friends here present their kind love to you, and
that you may continue in health and happiness, is the constant
prayer of

Sr

Your most dutiful Son.

Edw. Dawson, sculp.

Guide Sheets
Guide Sheet One

A

B

C

D

E

F

G

H

Copperplate Calligraphy

Guide Sheet Two

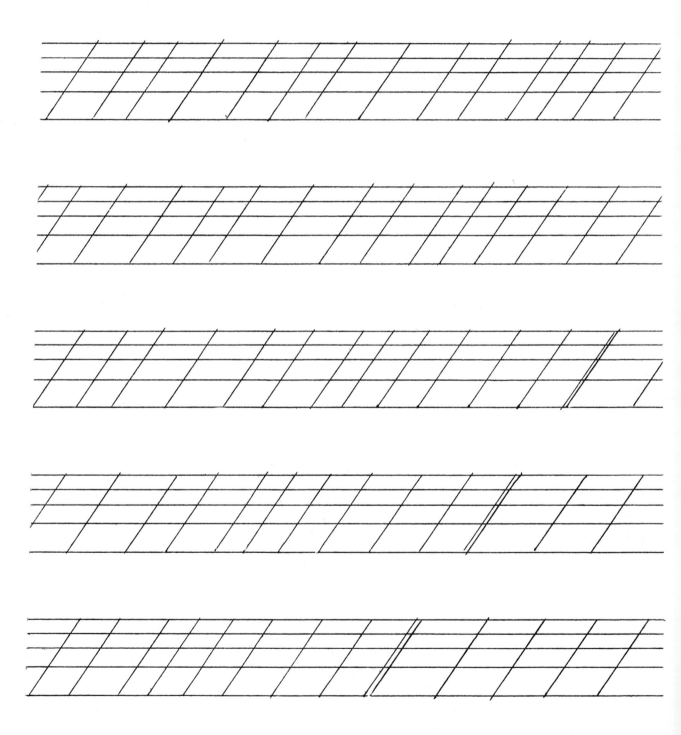

Guide Sheet Three

A

B

C

D

E

Guide Sheet Four

a

a

a

a

a

a

a

a

a

a

a

a

a

a

a

a

Guide Sheet Five